ARCHITECT

John Maltby

Images from the Photographs Collection
of the
Royal Institute of British Architects

by
Robert Elwall

© Royal Institute of British Architects 2000

Published by RIBA Publications
Construction House, 56-64 Leonard Street, London, EC2A 4LT

ISBN 1 85946 082 8

Product Code: 21002

Publisher: Mark Lane
Editor: Matthew Thompson
Commissioning Editor: Matthew Thompson
Design and typography by Red Hot Media, Suffolk
Printed and bound by Dennis Barber Graphics & Print, Suffolk

Table of Contents

Foreword

The RIBA Library Photographs Collection, containing over 650,000 images of architecture and related topics world-wide, is one of the most extensive and important in its subject field. The Collection's earliest images date from the Great Exhibition of 1851 and it includes the work of internationally renowned photographers such as Edouard Baldus, Francis Bedford and Tony Ray-Jones, as well as that of respected professional architectural photographers, among them Bedford Lemere, Dell & Wainwright and Sydney Newbery. In addition the Collection holds the archives of several of Britain's foremost twentieth-century architectural photographers such as John Maltby, Colin Westwood, John McCann, Henk Snoek and Alastair Hunter. The aim of this series of books is to make the Collection's riches better known and accessible to a wider audience. If you would like copies of any of the images featured or you are seeking a particular picture please do not hesitate to contact us. The Collection is available to all. Similarly if you know of photographs you think might suitably be lodged in our Collection and thus preserved for the benefit of future generations we would be delighted to hear from you.

The archive of John Maltby Limited was purchased in 1989 with the aid of a generous grant from the British Library Wolfson Foundation. Consisting of over 120,000 images in both negative and print form, the archive also comprises the firm's daybooks,

which provide a full record of what it photographed, together with appointment registers and a small amount of correspondence. All dates given in the captions have been taken from the daybooks and therefore represent the dates the photographs were taken and not necessarily those of the schemes depicted.

I am grateful to George Tanner, formerly of John Maltby Limited, for patiently answering my questions; to Mark Lane and Matthew Thompson at RIBA Publications; to A. C. Cooper (Colour) Ltd. for copy photography and printing; and to my wife, Cathy, for her customary organisational prowess. Their contribution highlights the essentially collaborative nature of even such a modest enterprise as this.

Robert Elwall
Photographs Curator

Introduction

John Maltby's career spanned five decades and produced some of the most enduringly evocative images of British architecture and design during the twentieth century, yet his name remains relatively unknown. There are a number of reasons for this undeserved obscurity. He never became official photographer to a leading journal with his own by-line, as, for example, Dell & Wainwright did at the *Architectural Review*, but remained a freelance with a varied clientèle. His work, though widely reproduced, was often uncredited. In addition, this work, embracing as it did a broad range of subject matter such as interior design, industry and product manufacture, as well as architecture, was far more diffuse than that of his more narrowly focused contemporary practitioners in architectural photography. Above all, however, the reason can be found in the innate modesty which once led Maltby to describe himself as simply 'a record photographer' and saw him steadfastly rebuff all attempts to intellectualise his work. While critics rightly laud the great masterpieces of architectural photography, it is often the seemingly more mundane but solidly professional compositions of photographers such as John Maltby which prove to have made the more telling contribution to architectural discourse.

Born in Manchester in 1910, Maltby was the son of a leading Quaker educationalist. Interestingly, several other architectural photographers active during the same period such as the long-

established Harry Bedford Lemere (1864–1944) and Mark Oliver Dell (1883–1959) shared a similar Quaker background. Having attended the Liverpool School of Art where he developed an interest in film and photography together with a keen compositional sense, Maltby attempted to establish his own photographic portrait business in Birkenhead. When this venture failed he moved to London where during 1935 he set up a photographic studio, initially in partnership with Noel Warner, in a Bloomsbury basement. The commission he obtained in that year, for a fixed fee of £3 per building, to take four views of every Odeon cinema proved highly lucrative and helped launch his career as an architectural photographer – architecture being a subject to which he was already drawn because it was the chosen profession of several of his former student colleagues.

Under Oscar Deutsch's enlightened patronage the Odeon chain expanded rapidly, acquiring existing cinemas and building new ones at breakneck speed. During 1937 alone 36 new Odeons were opened and by 1939 Maltby's stock boasted over 1,100 views of 250 different cinemas. These depictions of glittering art deco dream houses with their streamlined, cream-tiled fronts, brash lettering and boldly accentuated towers – a house style ushered in by Harry Weedon's design for the Odeon, Kingstanding (1935) *(fig. 2)* – have continued to provide some of the images most redolent of the 1930s. The view of the foyer of

Weedon's Odeon, Sutton Coldfield (1936) *(fig. 3)* conveys the aura of refulgent opulence imaginatively created to allow film-goers to forget temporarily the grim realities of their daily existence, as does Maltby's more detailed documentation of the Odeon's flagship cinema in Leicester Square, the interiors of which were ruthlessly ripped out during a modernisation programme during the 1960s *(fig. 6)*. Designed by Andrew Mather, the exterior of the Leicester Square cinema reversed the usual Odeon formula, substituting a striking all black granite façade for the usual cream faience tiling *(fig. 4)*. The Odeon commission led to further cinema jobs, pre-eminent among them the series of news cinemas photographed for their architect, Alister MacDonald, the son of the former Labour Prime Minister, James Ramsay MacDonald. Another such commission was the Monseigneur News Theatre designed in 1939 by Leslie Norton and Cecil Masey *(fig. 20)*.

The beginnings of Maltby's business coincided with a period of unprecedented vigour in British architectural photography with a clutch of firms and individuals such as Dell & Wainwright, Sydney Newbery and Herbert Felton producing work of outstanding quality[1]. This situation, which saw architectural photography attain a new prestige and influence, and led the *Architectural Review* in 1935 to acknowledge *'the ever-increasing debt architecture owes to the camera'* [2], was brought about by a number of factors: the

[1] For a more detailed discussion of photography during this period see Robert Elwall, *Photography Takes Command: the Camera and British Architecture 1890–1939* (London: RIBA Heinz Gallery, 1994)
[2] *Architectural Review*, vol. 75, Jan 1935, caption to plate iv

advent of Modernism; technological improvements; the growing use of photography for promotional and publicity purposes; and its increasingly important role in the content and design of architectural publications and exhibitions. The growth of Modernism, which emphasized new technology and man-made artefacts, not only accorded the 'machine art' of photography itself an enhanced status but also by encouraging architects to employ a wider range of materials – concrete, chromium, stainless steel, neon – afforded architectural photographers new possibilities for dramatic expression. These expressive possibilities were further extended by developments in camera technology, especially by the introduction during 1924 of the lightweight Leica, the ease of handling of which facilitated what László Moholy-Nagy termed 'the new vision'. Although little used for professional architectural work, the Leica nevertheless encouraged architectural photographers to ape, albeit in a more considered fashion, its often intuitive viewpoints with their larger, more immobile stand cameras. As the Studio Annual *Modern Photography* reported in 1932, *'The possibilities of views looking down, of views looking up, of extreme perspectives, of space dramatically conceived, the turning of the tables in scale by which a small object, suitably lighted, becomes dignified and impressive, and a large one, rendered small, takes on a new relation to its surroundings, all these things have been formed into a technical repertoire unknown to the photographer in the days before the war'* [3]. Bird's- and worm's-eye views such as that of

[3] Studio Annual. *Modern Photography,* ed C. G. Holme (London: The Studio, 1932), p. 7

Hornsey Town Hall *(fig. 22)* and close-ups were now added to the photographer's armoury which hitherto had been largely confined to the standard one- or two-point perspective. This expanded vision had the effect of calling attention to the role of the photographer himself. Whereas the camera had previously traded on the illusion that it was merely a mechanical recording device, once it became apparent that photography involved choice and interpretation, the men behind the lens assumed a new importance. They were assiduously courted by architects increasingly concerned to ensure the photographer's vision matched their own. It is no accident therefore that this period witnessed the development of relationships between architects, who hoped the images would successfully promote their work to prospective clients, and photographers, who were sympathetic to the architect's work: Le Corbusier and Claude Gravot or Richard Neutra and Julius Shulman, for instance. In a similar vein Maltby struck up a close relationship with Berthold Lubetkin, whose left-wing views he shared and whose work he photographed regularly from Highpoint I in 1935 up to and beyond Lubetkin's abrupt departure from mainstream architectural practice in 1950 with his resignation as Architect–Planner to the new town of Peterlee. The slightly elevated viewpoint from which Maltby photographed the exterior of Finsbury Health Centre not only gave a clearer indication of the complex's plan, but also allowed the centre to be seen in its urban context *(fig. 18)*. This was unusual as Modernist

buildings were most commonly pictured in isolation. More conventionally, Maltby's shot of the centre's foyer employed one of the favourite tricks of the period – the floor was deliberately wetted to enliven the scene in a way which paralleled the perspectivist Cyril Farey's popularization of the 'wet look' in architectural drawing *(fig. 19)*. Also beautifully captured was the Piranesian drama of Lubetkin's concrete staircase at Holford Square in what Lubetkin hailed as his favourite photograph of his work[4] *(fig. 47)*. Reproduced in the architectural press, images like these and of other Modernist works by architects such as Owen Williams and Joseph Emberton eloquently championed the cause of the International Style in the face of professional and public scepticism. As the critic P. Morton Shand observed, *'without modern photography modern architecture could never have been 'put across''*[5].

Architects were not alone in seeking to exploit the camera's capacity for promotion. During the inter-war years advertising expanded rapidly utilising to the full a wide range of graphic media and photography. In addition to Odeon, Maltby could count among his most regular clients a host of companies eager for photographs to boost their corporate image. These companies included: the Cement Marketing Company; the advertisers, Stoneham & Kirk; and the Adamite Company Limited, a firm specializing in interior and exterior finishes that first

[4] In conversation with the author
[5] *Architectural Review*, vol. 75, 1934, p. 12

commissioned Maltby in 1939 and, in a remarkable but by no means unique tribute to Maltby's ability to retain his clients, continued to commission him 40 years later. Another firm to make repeated use of Maltby's services was The Benjamin Electric Limited which issued its photographers with two pages of instructions detailing its requirements: *'Positions showing dark shadows or abnormal views should be avoided. This particularly applies to bulky or dark objects in the foreground. It may be advantageous to raise the camera above normal viewpoint, but this will be apparent from the size and nature of the interior ... When operatives are included in the scene, they should be shown in natural positions as if engaged on their normal duties ... Prints should have as much luminosity and details in the shadows as possible, a slightly soft effect is preferable to a very bright print'* [6]. The most prestigious commercial client with whom Maltby first came into contact during these inter-war years, however, was undoubtedly the window manufacturer, Crittall, a firm which played a leading role in the development of the Modern Movement and whose commitment to good photography was underlined not just by its employment of Maltby but also of John Havinden, one of the period's most distinctive and outstanding photographers. Maltby's work for Crittall was to stretch over four decades and involved not just photography of its products *in situ* but also of every stage of the production process in its various factories such as those at Witham and Braintree *(fig. 29)*. Among the schemes Maltby

[6] Undated typescript in Maltby archive

photographed for Crittall were Owen Williams's Pioneer Health
Centre at Peckham, London (1935) *(fig. 10)*; the Royal Festival Hall
(1951) *(fig. 42)*; and John Hutton's elegant engraved glass window
at Coventry Cathedral (1962) *(fig. 68)*. Photographs for firms such
as these gained wide currency as they were not only reproduced
in corporate literature but also in the technical press.

The technical and professional press constituted the other main
block in Maltby's client base with his work being featured in
Architectural Review, the most impassioned standard-bearer of
Modernism, and more regularly in its more practical companion,
the *Architects' Journal*, for which he photographed the Boots
'Drys' building, Nottingham *(fig. 23)*. His pictures also appeared in
Architecture Illustrated which, as its name suggested, was full of fine
photographs and virtually no text thus underlining the increasing
supremacy of photography in the presentation of new buildings
at the expense of the perspective drawings from the Royal
Academy's annual exhibition which had filled the pages of the
magazine's predecessor, *Academy Architecture*. Joining these in
showcasing Maltby's work was the *Architect & Building News*,
which over the previous decade, under the tutelage of John
Summerson, among others, had built up a reputation for fine,
though somewhat unimaginatively laid out, photography through
its reproduction of images of architecture overseas by F. R.
Yerbury and at home by Herbert Felton. The shots of the Daily

Express, Manchester *(figs. 24 & 25)* and Blackpool Pleasure Beach *(figs. 26 & 27)*, the latter demonstrating that Modernism was not all stripped austerity but could be fun, were taken for the *Architect & Building News* which the distinguished American critic, Henry-Russell Hitchcock, described as *'an excellent English magazine of architecture'* [7].

Together with those of the Odeon cinemas, two photographs in particular – those of Battersea Power Station *(fig. 1)* and the Lido at Saltdean *(fig. 15)* – have helped to fix our image of the British architectural scene during the thirties. Although Scott's design for the façade of Battersea with its art deco brick detailing offended more doctrinaire Modernists, the power station nevertheless became a potent symbol of modernity. Nowhere was this better conveyed than in Maltby's night shot where the floodlit power station gleams like a beacon of hope in an otherwise all-engulfing Stygian gloom. In exemplifying the period's faith in redemption through technology, the photograph stands in a line of descent that includes images such as Charles Sheeler's Ford Plant, River Rouge, Detroit (1927) and Margaret Bourke-White's Rosenbaum Grain Corporation (1931). When Battersea was extended in the 1950s its new photographers, for example Alex Starkey for *Country Life* and Eric de Maré, significantly still chose to view it in a similar fashion to Maltby. In addition to its technological optimism, Maltby's glass plate also reveals another contemporary

[7] *Architectural Record*, vol. 65, Feb 1929, p. 209

trend in the burgeoning appreciation of the drama inherent in night architecture that saw illumination become an integral element in design. If Battersea was compared by contemporaries to the buildings in Fritz Lang's *Metropolis*, the title of another Lang film *They Live by Night* encapsulates how neon and the adroit deployment of floodlighting could transform structures that by day appeared unremarkable. By contrast, Saltdean Lido, with its white curvilinear forms and nautical air derived from Mendelsohn and Chermayeff's De La Warr Pavilion at nearby Bexhill (1935), exemplifies the 1930s obsession with the therapeutic properties of bathing, fresh air and the sun.

By 1939 Maltby had established a reputation as one of the country's top architectural photographers, but it was after the Second World War when his career really blossomed. By this time many of the leading lights of architectural photography in the inter-war years had faded from the scene. The curtain finally fell on Harry Bedford Lemere's long career with his death in 1944, the same year as the Liverpool-based Edward Stewart Bale also died. In 1946 the relatively short-lived but highly influential partnership of Dell & Wainwright was dissolved, while Herbert Felton largely abandoned the photography of contemporary work, preferring instead to concentrate on ecclesiastical architecture and landscape subjects. The photographic documentation of the rebuilding of post-war Britain was thus

mostly in the hands of Maltby and a new generation of architectural photographers. Among these the most important were John Pantlin, regularly commissioned by the Architectural Press; Colin Westwood, who for a short time worked for Maltby before setting up his own business in 1948; Bill Toomey, from 1951 the official photographer to the Architectural Press; Michael Wickham, who held a similar position at the increasingly influential *House & Garden*; and Sam Lambert, former news editor of the *Architects' Journal*, whose photographs appeared both there and in *Architectural Design*, which by the late 1950s was coming to supplant the *Architectural Review* as the mouthpiece of the architectural avant-garde. This roll-call serves to underline the split in architectural photography between those who photographed contemporary output and those whose subject matter was almost entirely historical. The **marvel**lous Atget-inspired Edwin Smith and to a lesser extent, Eric de Maré, may be placed in the latter category. Few photographers straddled this divide and there is very little work of a historical nature in Maltby's archive.

As a conscientious objector Maltby did not fight in the war and although he continued to take some photographs his business effectively closed. An entry in his daybook suggests that he spent the war years working in the Furzehill Laboratory at Elstree before reopening his studio during 1945. Work continued to be scarce in the immediate post-war period as building activity was

hampered by shortages of labour and materials. The photographer's lot was rendered even more onerous by difficulties in obtaining film stock and by the petrol rationing, which by 1951 had forced Maltby to rein in his passion for luxury cars and swap his 30 hp Lagonda for an altogether more modest Morris 8 Tourer. One of his more interesting commissions at this time, which included coverage of the Basil Spence designed *Britain Can Make It* exhibition (1946) for its organiser, the Council of Industrial Design, came from the Architectural Press. The brief was to photograph a series of pub interiors and decoration for a special issue of *Architectural Review* entitled 'Inside the Pub' which appeared in October 1949. Written by Maurice Gorham and H. McG. Dunnett and illustrated in part with colour drawings by Gordon Cullen, the issue was very much in the *Architectural Review's* campaigning tradition seeking to *'discover ways and means of recreating the familiar atmosphere of the traditional pub without resorting to period copyism'* [8]. Reissued, with some slight rearrangement of the material, in book form in the following year, it included several of the specially commissioned Maltby images *(fig. 36).*

Until 1954, when they were finally abolished, a system of building licenses was in operation, the aim of which was to channel such scanty resources as were available into the priority areas of housing and schools. Consequently, these tended to be the subjects that

[8] J. M. Richards, 'Foreword' in Maurice Gorham and H. McG. Dunnett, *Inside the Pub* (London: Architectural Press, 1950), p. 12

Maltby photographed most. Of particular importance was his coverage of Hertfordshire County Architects Department's pioneering school building programme largely masterminded by Stirrat Johnson-Marshall and the able young team he assembled (figs. 34 & 35). Marked by its collaborative and developmental nature and by its emphasis on architecture as social service, the programme made innovative use of prefabrication to deliver the number of schools urgently required. Although subtly scaled to children's needs and ingeniously planned, the schools were visually ascetic and as a result photographs generally fail to convey a proper appreciation of just how progressive they were. The story of the secondary school at Hunstanton, designed by Alison and Peter Smithson and photographed by Maltby on its completion in 1954, affords a telling contrast (figs. 48 & 49). In essence Hunstanton represented a deliberate rejection of the principles underlying Hertfordshire's approach to school design. Not only was it conceived as a one-off rather than a prototype, it also shunned modular construction in favour of a collection of off-the-peg components. Above all, however, it repudiated the self-effacing teamwork characteristic of the Hertfordshire programme, replacing it with a ruthlessly powerful personal design statement that the critic Reyner Banham hailed as a key example of the emerging New Brutalism. Whereas the Hertfordshire schools were often photographed in use, the Smithsons ordered the removal of all furniture before Maltby took his photographs, thus ensuring that the logical purity of their design

was compellingly depicted. For Banham one of the key tenets of New Brutalism was memorability of the building as image [9] and at Hunstanton this quality was accentuated by Maltby's photographs. Endlessly reproduced the world over, these images have helped to cement the school's reputation as one of the most outstanding works of British post-war architecture presaging High Tech and the work of architects such as Cedric Price, Norman Foster and Richard Rogers. The Braithwaite water tower has proved a particularly resonant symbol being echoed, for example, in Team 4's Reliance Controls, Swindon (1967). The glossy perfection of the photographs, however, traps the school in time and masks its many structural and planning shortcomings, thus demonstrating the gap between image and actuality which first aroused critics' misgivings during the 1930s when Dell & Wainwright in particular were attacked for flattering Modern Movement buildings to a pernicious degree. These concerns have continued to reverberate ever since with Sir John Summerson, for example, ruing: *'All buildings now are assessed on photographs and not on the real thing, the thing you feel and touch and that you leave with a distinct impression. Photographs are the devil'* [10]. The Hertfordshire–Hunstanton dialectic shows at once the limitations of photography and its power to shape architectural criticism and practice.

Maltby's firm was at its most productive during the 1950s and 1960s. Whereas nearly 5,000 views were added to stock in the

[9] *Architectural Review*, vol. 118, Dec 1955, p. 361
[10] *Building Design*, no. 301, 4 June 1976, p. 10

1930s, the comparative figures for these two decades were 29,000 and 40,000, respectively. At its peak the firm employed four photographers, two printers and several clerical staff. Progress photography for building contractors such as McAlpine and Laing tended to be handled by the more junior photographers, one of whom, James Hall, had previously been employed by the architectural photographer Edward Stewart Bale. The more prestigious jobs were handled by Maltby himself or by George Tanner, who Maltby had headhunted and who joined the firm as his assistant in 1954. The two photographers had first met at the Festival of Britain in 1951 where Tanner was photographing for the Council of Industrial Design and soon discovered their work betrayed a similarity of approach, particularly with regard to lighting and viewpoint. Whereas Maltby was entirely self-taught, Tanner, after a period as a press photographer with the *Gloucestershire Echo* and the *Cheltenham Chronicle* and then during the war as a member of the Mobile Field Photographic Unit, studied photography at the Regent Street Polytechnic. There one of his tutors was Margaret Harker, herself a noted architectural photographer. Tanner was to become a director of the firm during 1960 and then, after Maltby's death, its owner.

After the war the firm largely abandoned glass negatives in favour of Ilford film stock. The most common format is half-plate with

Rolleiflex negatives being used for 'action' shots such as that of the reconstruction of the House of Commons *(fig. 31)*. Maltby's preferred camera was a Sanderson, a perennial favourite of architectural photographers, which he continued to use even when Tanner and the firm's other photographers turned to Sinars. Although there were experiments with various colour processes, black and white predominated for almost the entirety of the company's existence. Surviving daybooks, correspondence and appointment registers make it possible to construct a fascinating picture of the daily routine of the firm. To give a flavour, during 1953 Maltby wrote to a prospective client:

'For photographs of completed buildings where a preliminary visit is frequently necessary and where it is essential for exterior views, to have suitable weather, and, for interiors, to arrange the furniture and use additional lighting, a fee of £1.11.6d. per photograph would apply. Should one photograph only be required necessitating a special visit there is a minimum fee of two guineas. Where travelling outside approximately a twenty mile radius is involved there is a charge of 6d. per mile' [11].

The often hazardous nature of architectural photography is revealed by a later suggestion from the same client that for a good viewpoint of its work it was possible *'to climb up the inside of a 70 ft. high chimney stack on the site'* [12].

[11] From letter by Maltby to Messrs Rush & Tompkins Ltd dated 11 Dec 1953 in Maltby archive
[12] From letter by V. S. Smith of Rush & Tompkins Ltd to Maltby dated 25 Mar 1954 in Maltby archive

During the 1950s the firm's output strongly reflected the architectural themes of the decade: the initial dominance of local authority architecture seen for instance in its work for that socially-conscious leviathan, the London County Council; the irresistible spread of the Festival style from New Towns to coffee bars; the search for technological solutions to speed up the reconstruction of the urban fabric; the growing confluence of design and architecture and the attempt to integrate architecture and art more fully; the resurgence of private practice in the latter half of the decade with newly formed firms such as Chamberlin Powell & Bon coming to the fore; and the developer-led building boom, which at the close of the 1950s signalled an end to austerity and the arrival of a new age of affluence soon to be transmuted into the swinging sixties. These themes were also mirrored in the firm's greatly expanded network of clients. One of the most important newcomers was the glass manufacturer, Pilkington, for whom Maltby undertook numerous commissions of a kind which before the war had been entrusted to John Somerset Murray, who unusually combined the role of photographer with that of electronics engineer. Others such as Heals and the furniture manufacturers, Hille, together with magazines such as *Ideal Home* and *Modern Woman* underlined the increasing amount of time the firm spent photographing interiors. Manufacturers and journals like these played a vital role in the shaping of public taste and the mounting popularity of open-

planning *(fig. 45)* and the 'Contemporary' look in the home *(fig. 66)*, for instance, are well illustrated in Maltby's archive. His photographs of labour-saving devices and gleaming new kitchens or voyeuristic peeps into the homes of celebrities, such as racing driver Stirling Moss or singer Alma Cogan, were hugely influential *(figs. 52 & 58)*. Product companies were quick to realise the advertising potential of these images as a letter to Maltby from the public relations department of the Persil Home Washing Bureau illustrates: *'I am enclosing a giant packet of PERSIL which I hope will be useful to you when dressing sets for kitchen interiors or in washing machine photographs. I feel it may be helpful to you to have in your 'props' and may save you the inconvenience of buying a packet when the need arises'* [13]. These interior views reveal an accomplished manipulation of lighting with cast shadows and reflections skilfully harnessed to enhance the composition of the picture, the result being in Tanner's words that *'the eye should be led round a picture by line and tone to the centre of interest, but not held captive there, so it can travel round again'* [14].

Together with interiors, two other subjects were starting to play a much larger role in the firm's business – exhibition design and industry. With new building at a premium, exhibition design assumed a new importance both during and after the war. The most obvious manifestation of this trend was the Festival of Britain, which provided the British public with its first real taste of

[13] Letter dated 19 May 1954 in Maltby archive
[14] Quoted in draft typescript of article by Sidney Ray, 1989, in Maltby archive

Modernism. Maltby photographed much of the Festival site and the newly created Pleasure Gardens in Battersea Park where the idea of the Festival as a tonic to a nation wearied by war and economic depression was most readily apparent *(fig. 43)*. Similarly, his night shot of Powell & Moya's elegant, Brancusi-inspired Skylon fittingly expresses the Festival organisers' hope that Britain would break free from the shackles of post-war austerity *(fig. 41)*. The rise of exhibition design encouraged the emergence of a new breed of professional exhibition designers such as James Gardner and Beverley Pick, the latter being one of Maltby's most regular clients, together with firms that combined the skills of architect and designer thereby allowing them to encompass a much broader range of work. Among these were Ward & Austin and in particular the Design Research Unit, whose members included Misha Black and Milner Gray. Maltby photographed extensively for the DRU and his print files demonstrate how successfully the group achieved its avowed purpose *'to present a service so complete that it could undertake any design case which might confront the State, Municipal Authorities, Industry and Commerce'* [15]. One example must suffice here, that of the S.S. Oriana, launched during 1959, for which the DRU was responsible for the ship's badge on its bows and the co-ordination of the design for the public rooms *(fig. 67)*.

Maltby's love of well-engineered machinery shows through in his photographs of industrial subjects taken for bodies such as the

[15] From letter by Milner Gray to Cecil D. Notley quoted in Avril Blake, *Misha Black* (London: Design Council, 1984), p. 30

British Iron and Steel Federation. In their chiaroscuro lighting and composition as well as their admiration for the men involved, images like the **Arc furnace teeming from ladle** *(fig. 37)* recall those of Walter Nurnberg who, after the Second World War, established his reputation as the leading chronicler of British manufacturing industry. Today these photographs have acquired an added piquancy in becoming hauntingly melancholic evocations of an industrial world we have largely lost.

The trend towards greater coverage of interiors evident during the 1950s gathered pace in the ensuing decades. Symptomatic of this is the large amount of material in the archive shot for Terence Conran and his newly created Habitat outlet, the first shop of which in the Fulham Road Maltby photographed on the eve of its opening on 11 May 1964 *(fig. 75)*. The simplicity of the interior and the straightforward manner in which the goods were displayed, both clearly apparent in Maltby's photograph, were key ingredients in the retailer's phenomenal success. On a more purely architectural note, Maltby covered the great expansion in tertiary education during the 1960s, as well as the long-running saga of the Barbican development that yielded in excess of 10,000 negatives *(fig. 80)*. By the end of the decade, however, it is obvious that the commissions to photograph architecture at its cutting edge were going to a new generation of photographers whose work was more in keeping with its harsher aesthetic sensibilities.

The more hard-edged compositions of Richard Einzig and Henk Snoek or, at the opposite end of the photographic spectrum, the 'live', seemingly casual, 35mm pictures of John Donat, who was concerned to show buildings in use, now dominated the pages of the architectural press. Maltby's rich archive, however, presents more than just a snapshot of British architectural endeavour in the middle third of the twentieth century. Rather it is a social document allowing a unique insight into the changing face of Britain at a time of rapid technological change. As such it deserves to be better known.

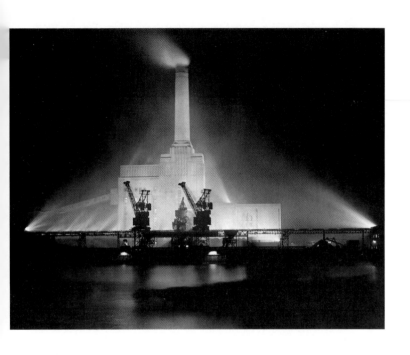

fig. 1

**Battersea Power Station,
London** (1935)

Designers:
*Sir Giles Gilbert Scott
and James Theodore Halliday*

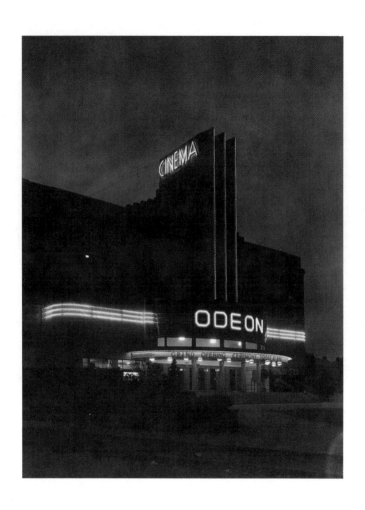

fig. 2

**Odeon, Kingstanding,
Birmingham** (1935)

Architect:
Harry William Weedon

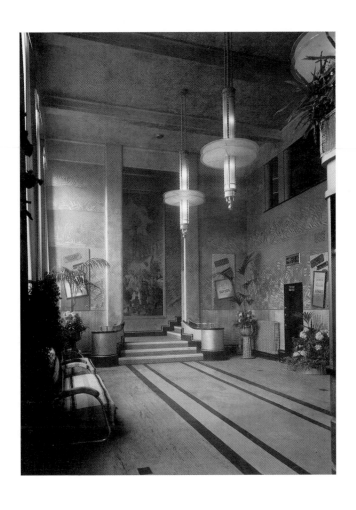

fig. 3

**Foyer, Odeon,
Birmingham Road, Sutton Coldfield** (1936)

Architect:
Harry William Weedon

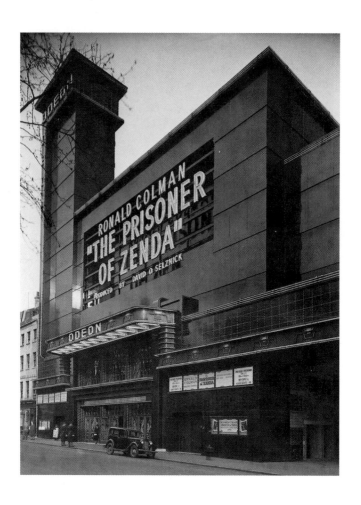

fig. 4

**Odeon, Leicester Square,
London** (1937)

Architects:
*Andrew Mather
and Harry William Weedon*

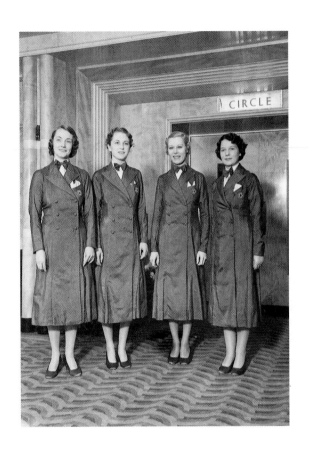

fig. 5

**Usherettes at the opening of the Odeon,
Leicester Square, London** (1937)

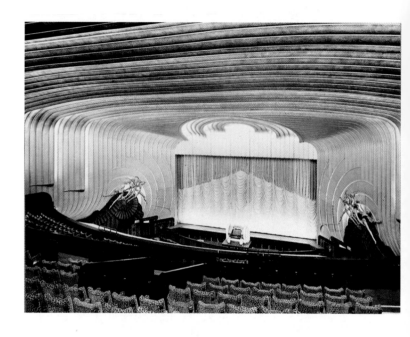

fig. 6

**Auditorium, Odeon,
Leicester Square, London** (1937)

Architects:
*Andrew Mather
and Harry William Weedon*

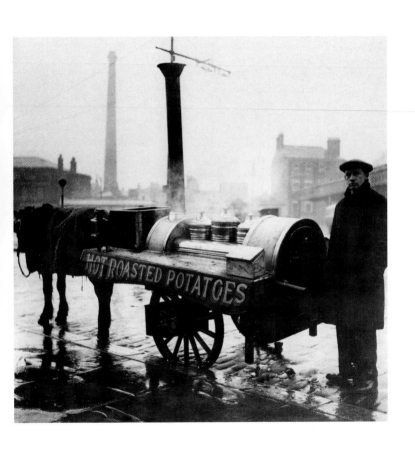

fig. 7

Roasted potato seller
(1937)

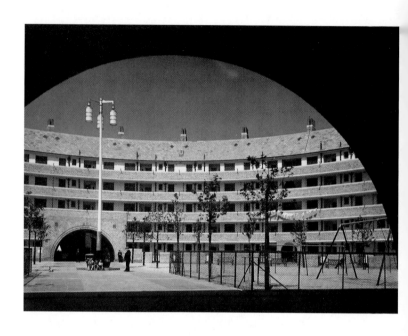

fig. 8

**St. Andrew's Gardens, Brownlow Hill,
Liverpool** (1935)

Architect:
Sir Lancelot Keay

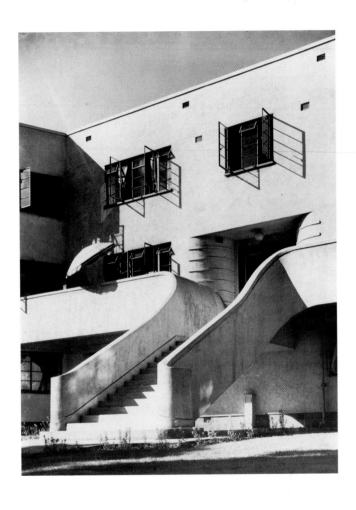

fig. 9

**Flats for developers Haymills,
Wembley, London** (1935)

Architects:
Welch Cachemaille-Day & Lander

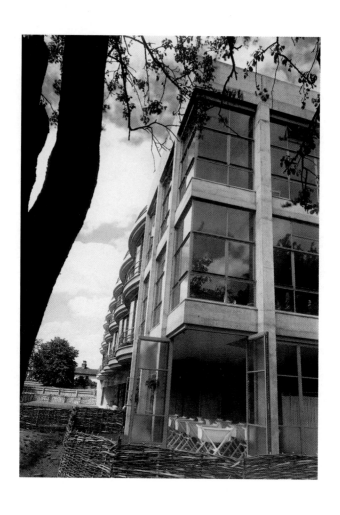

fig. 10

**Pioneer Health Centre, St. Mary's Road,
Peckham, London** (1935)

Architect/Engineer:
Evan Owen Williams

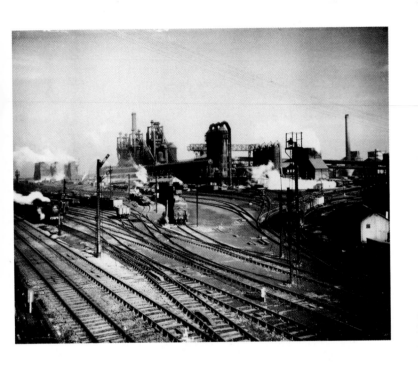

fig. 11

Stewarts and Lloyds steelworks at Corby
(1936)

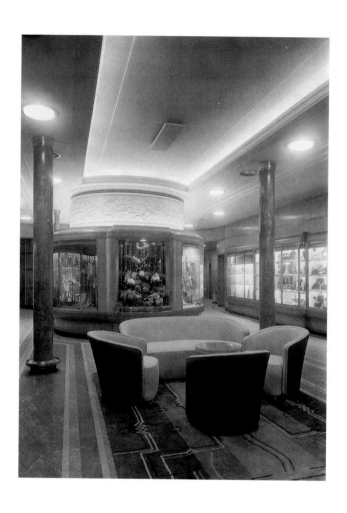

fig. 12

**Austin Reed shop on the promenade deck,
R.M.S. Queen Mary** (1936)

Architect:
Percy James Westwood

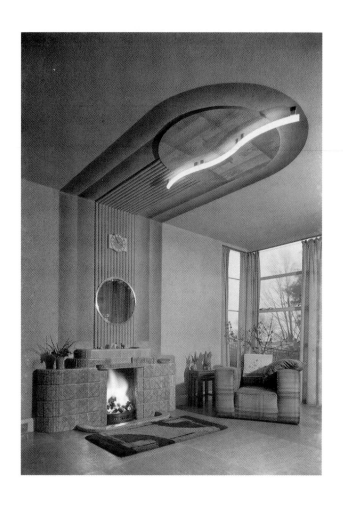

fig. 13

Typical living room in Art Deco style
(1936)

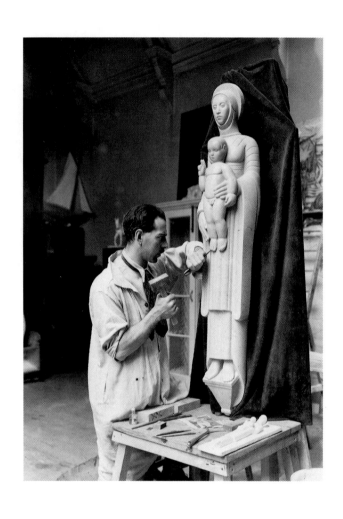

fig. 14

Edward Bainbridge Copnall sculpting a Madonna & Child
(1937)

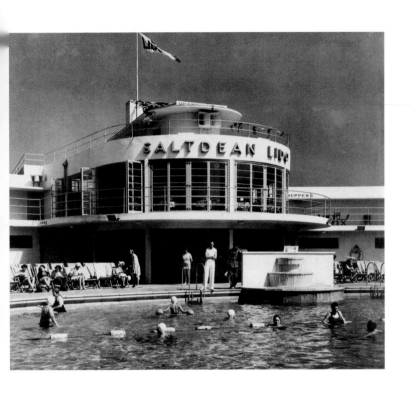

fig. 15

Saltdean Lido
(1938)

Architect:
Richard William Herbert Jones

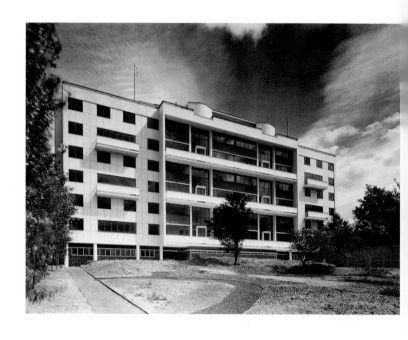

fig. 16

**Garden front, Highpoint II,
Highgate, London** (1938)

Architects:
Lubetkin & Tecton

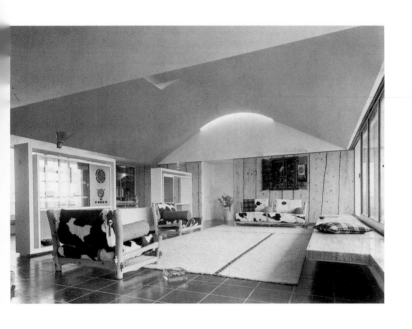

fig. 17

**Sitting room of Lubetkin's penthouse flat,
Highpoint II, Highgate,
London** (1938)

Architects:
Lubetkin & Tecton

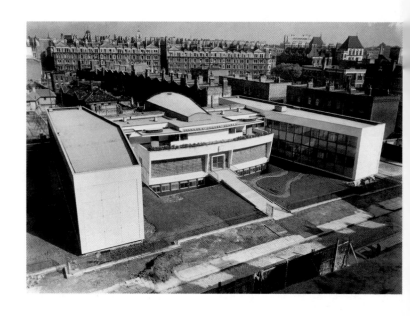

fig. 18

**Finsbury Health Centre, Pine Street,
Finsbury, London** (1938)

Architects:
Lubetkin & Tecton

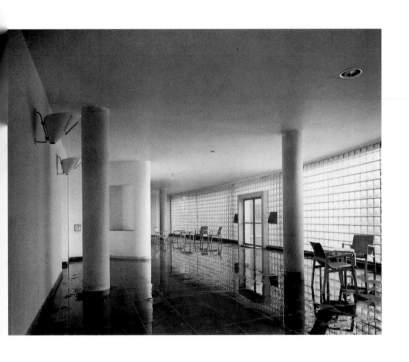

fig. 19

**Foyer, Finsbury Health Centre, Pine Street,
Finsbury, London** (1938)

Architects:
Lubetkin & Tecton

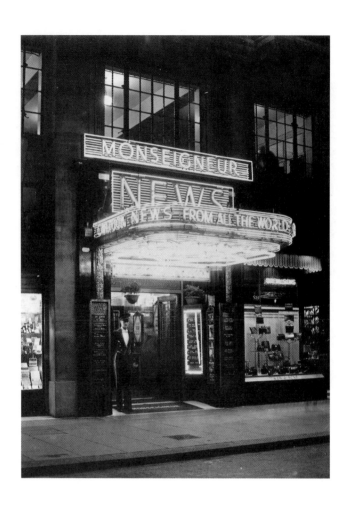

fig. 20

**Monseigneur News Theatre,
523 Oxford Street, London** (1939)

Architects:
Leslie C. Norton and Cecil Masey

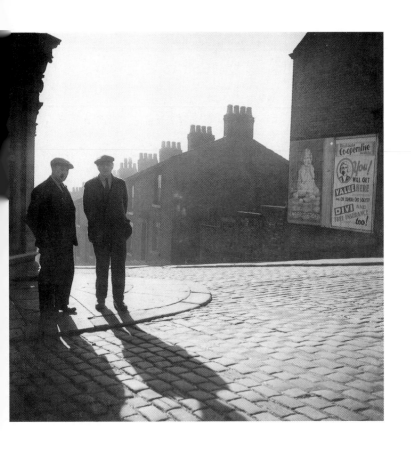

fig. 21

'Up North!' [Blackburn]
(1938)

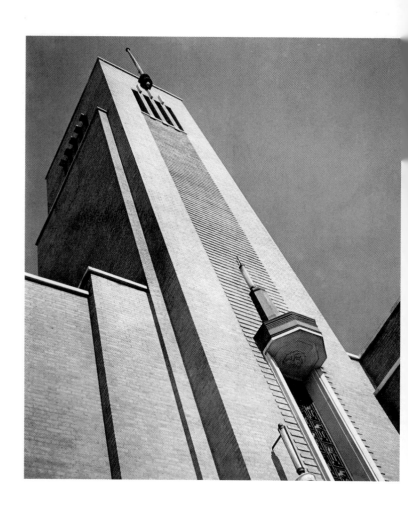

fig. 22

**Hornsey Town Hall, Haringey,
London** (1939)

Architect:
Reginald Harold Uren

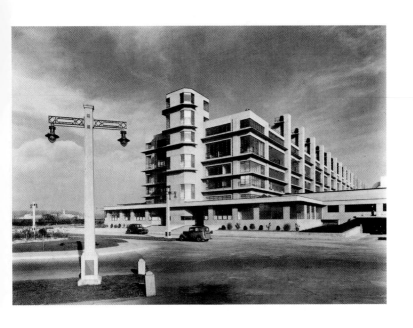

fig. 23

**Entrance façade, 'Drys' building,
Boots factory, Beeston,
Nottinghamshire** (1938)

Architect/Engineer:
Evan Owen Williams

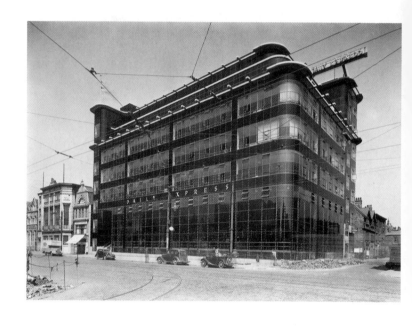

fig. 24

**Daily Express, Great Ancoats Street,
Manchester** (1939)

Architect/Engineer:
Evan Owen Williams

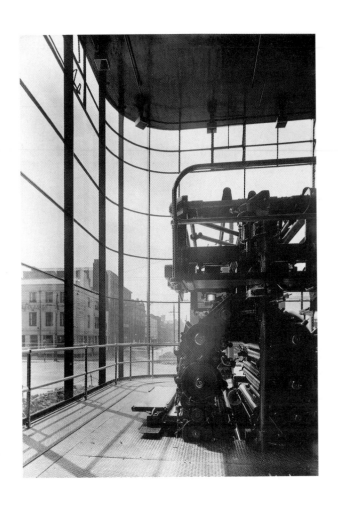

fig. 25

**Machine hall, Daily Express,
Great Ancoats Street, Manchester** (1939)

Architect/Engineer:
Evan Owen Williams

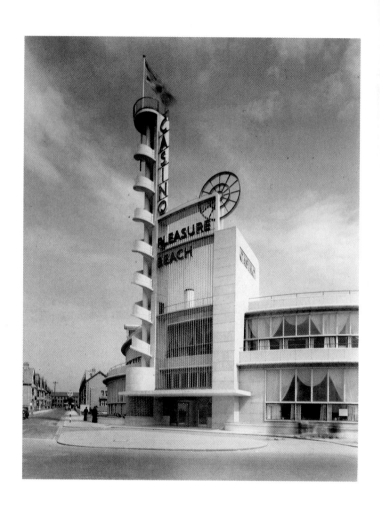

fig. 26

Casino, Blackpool Pleasure Beach
(1939)

Architect:
Joseph Emberton

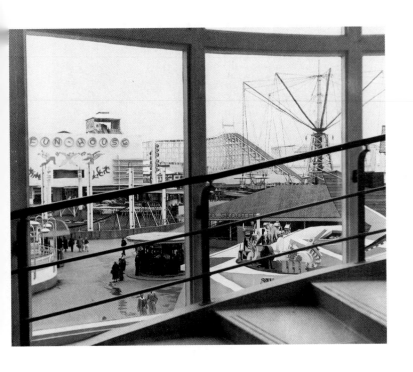

fig. 27

Blackpool Pleasure Beach
(1939)

Architect:
Joseph Emberton

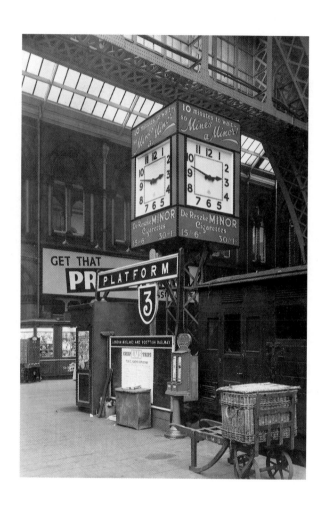

fig. 28

**Platform 3, St. Pancras Station,
London** (1939)

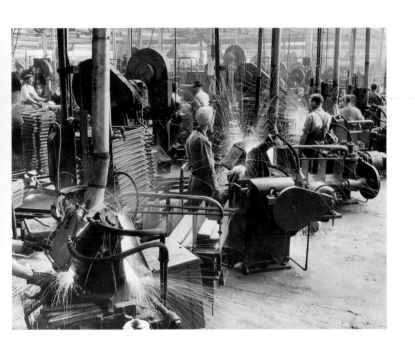

fig. 29

Crittall's works at Witham
(1947)

57

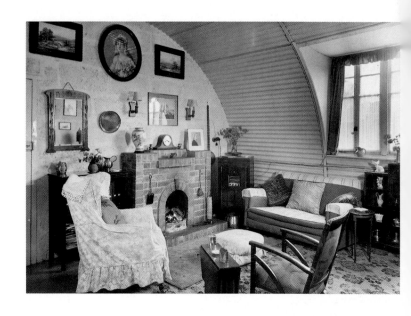

fig. 30

**Living room in Nissen hut,
Shirehampton, Bristol** (1947)

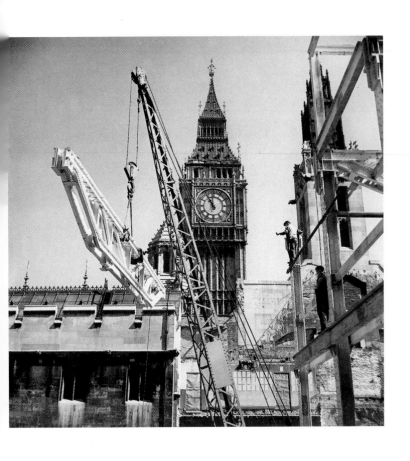

fig. 31

**Reconstruction of Houses of Parliament,
London** (1947)

Architects:
*Sir Giles Gilbert Scott
and Adrian Gilbert Scott*

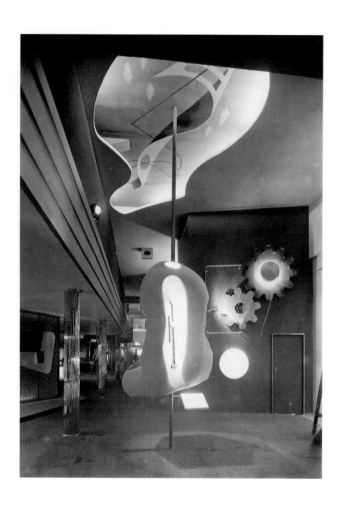

fig. 32

**British Iron & Steel Federation stand,
Ideal Home Exhibition, London** (1948)

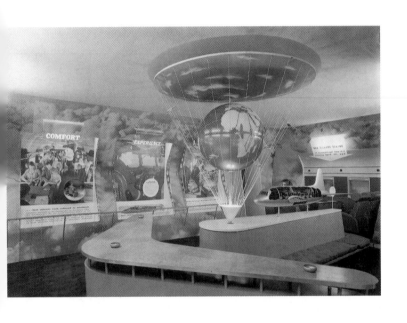

fig. 33

**BOAC stand, British Industries Fair,
Earl's Court, London** (1948)

Designer:
Beverley Pick

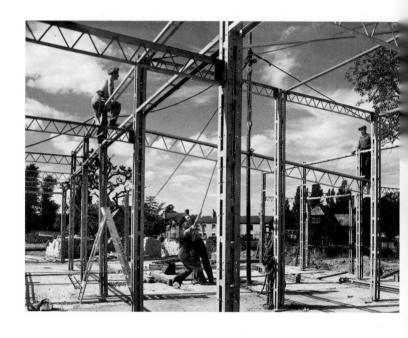

fig. 34

**Construction of primary school,
Leavesden** (1949)

Architects:
Hertfordshire County Architects Department

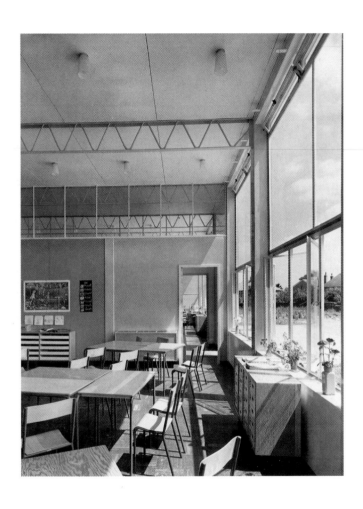

fig. 35

**Strathmore Avenue School,
Hitchin** (1949)

Architects:
Hertfordshire County Architects Department

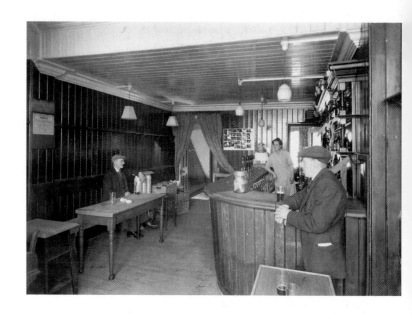

fig. 36

**Pub in the Mile End Road,
London** (1949)

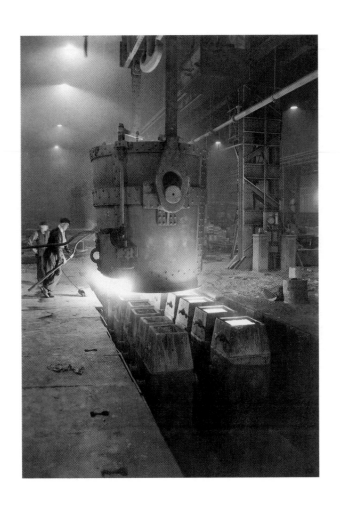

fig. 37

**Arc furnace teeming from ladle,
steelworks, Sheffield** (1949)

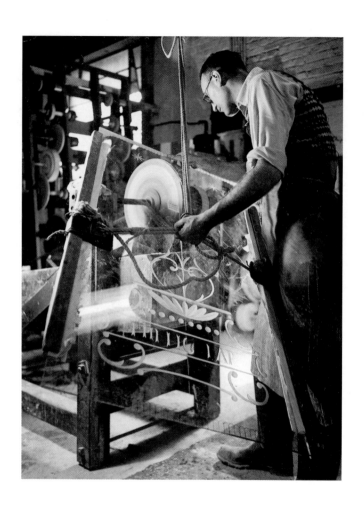

fig. 38

**Brilliant cutting at James Clark & Eaton,
London** (1949)

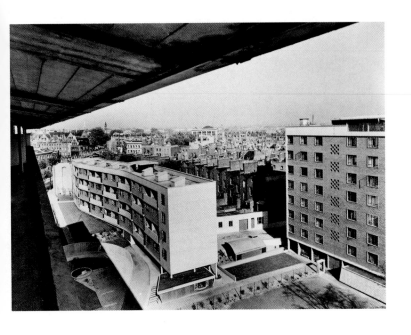

**Spa Green Estate,
Rosebery Avenue, London** (1950)

Architects:
Tecton
Executive Architects:
Skinner & Lubetkin

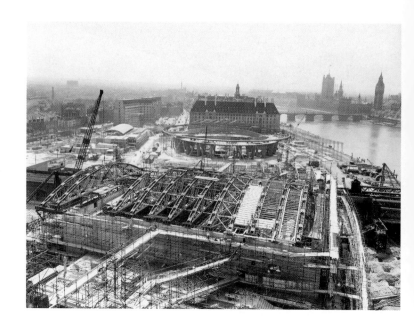

fig. 40

**Festival of Britain site under construction,
including Dome of Discovery and Royal Festival Hall,
seen from Shot Tower** (1950)

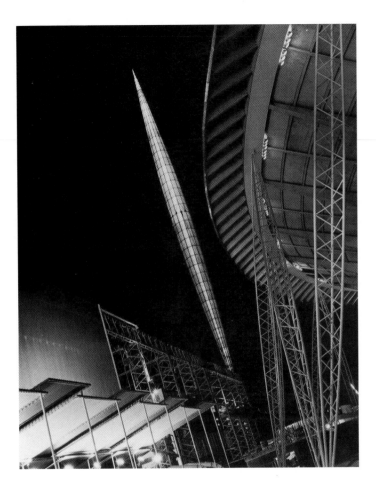

fig. 41

**Skylon and the Dome of Discovery,
Festival of Britain, South Bank,
London** (1951)

Architects:
Powell & Moya / Ralph Tubbs

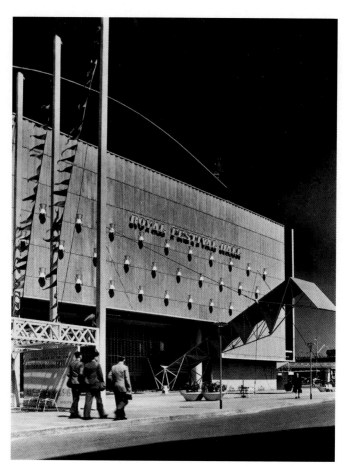

fig. 42

**Belvedere Road entrance to the Royal Festival Hall
with Trevor Dannatt's temporary canopy,
Festival of Britain, South Bank,
London** (1951)

Architects:
London County Council Architects Department

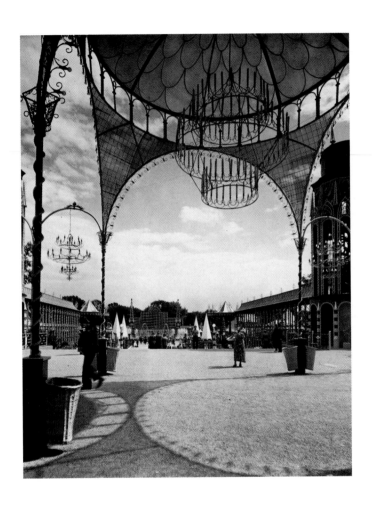

fig. 43

**Festival Gardens, Battersea Park,
London** (1951)

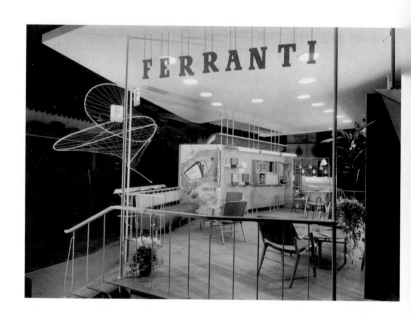

fig. 44

**Ferranti exhibition stand, Radio Show,
Earl's Court, London** (1952)

Architect:
Fritz Gross

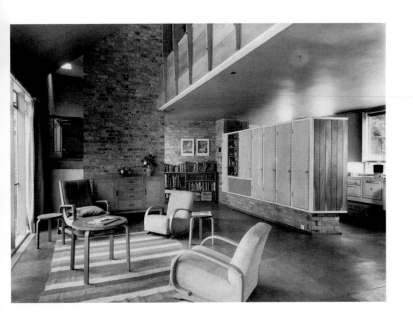

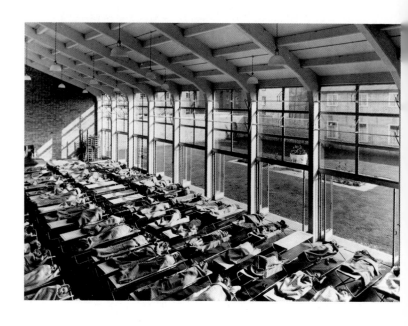

fig. 46

**LCC Open Air School,
Bow Road, London E2** (1953)

Architects:
Farquharson & McMorran

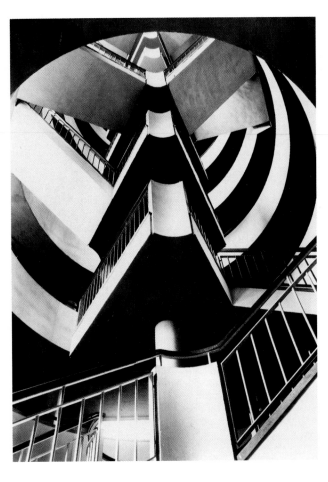

fig. 47

**Central staircase of Bevin Court,
Holford Square Estate,
Finsbury, London** (1954)

Architects:
Tecton
Developed and Executed by:
Skinner Bailey & Lubetkin with A. Green

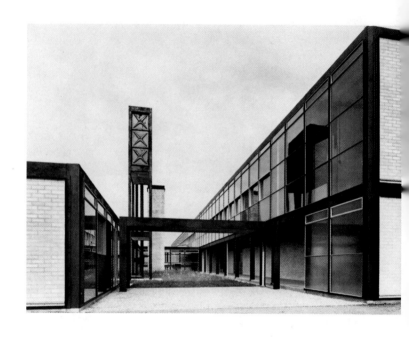

fig. 48

**Secondary school,
King's Lynn Road, Hunstanton** (1954)

Architects:
Alison & Peter Smithson

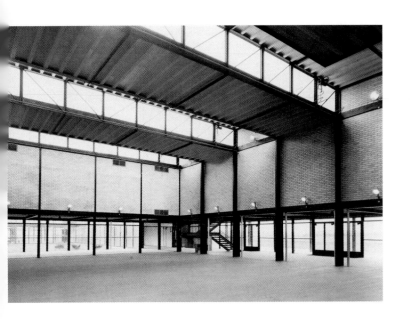

fig. 49

Secondary school,
King's Lynn Road, Hunstanton (1954)

Architects:
Alison & Peter Smithson

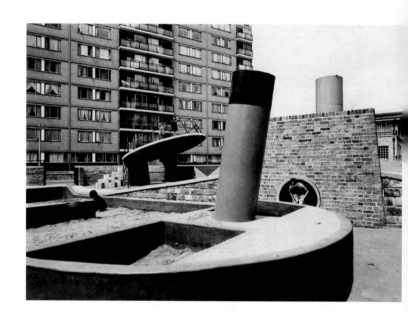

fig. 50

**Churchill Gardens,
Pimlico, London** (1956)

Architects:
Powell & Moya

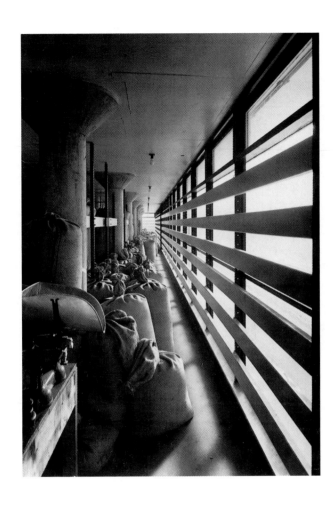

fig. 51

**Seed factory for Cooper Taber & Co.,
Station Road, Witham** (1956)

Architects:
Chamberlin Powell & Bon

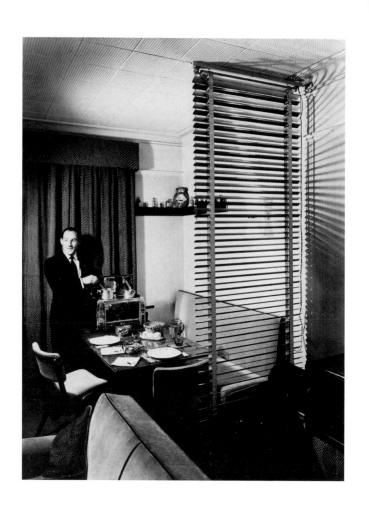

fig. 52

Stirling Moss at home
(1956)

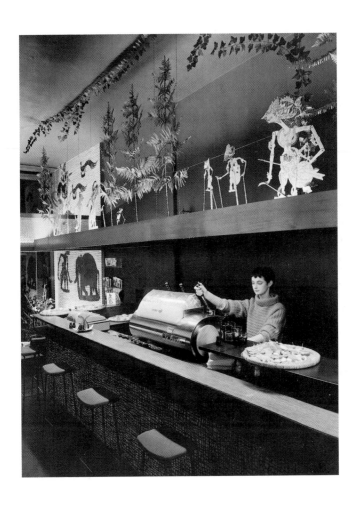

fig. 53

**Wayang Coffee Lounge,
Earl's Court Road, London** (1956)

Architect:
Lucas Mellinger

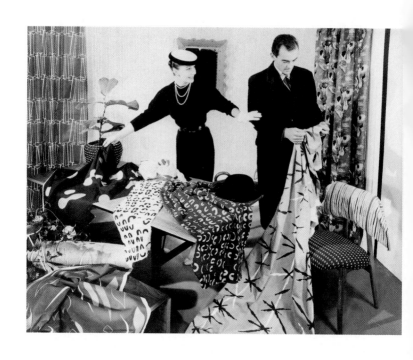

fig. 54

'Selecting fabrics at Heal's'
(1956)

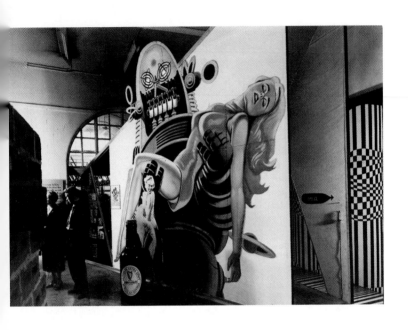

fig. 55

**Group Two exhibit, *This Is Tomorrow* exhibition,
Whitechapel Art Gallery, London** (1956)

Artists:
*Richard Hamilton, John McHale,
John Voelcker*

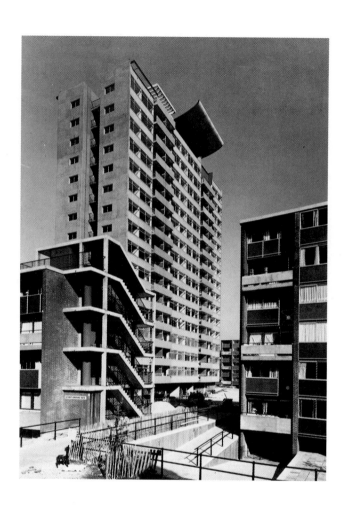

fig. 56

**Golden Lane Estate,
City of London, London** (1957)

Architects:
Chamberlin Powell & Bon

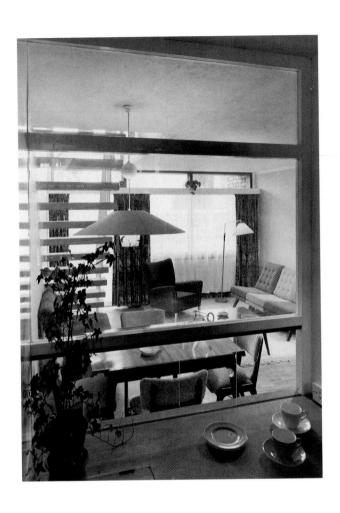

fig. 57

**Golden Lane Estate,
City of London, London** (1956)

Architects:
Chamberlin Powell & Bon

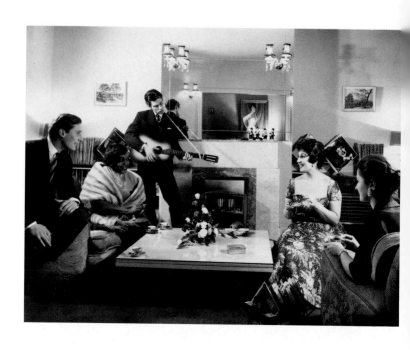

fig. 58

Alma Cogan's flat,
Seymour Place, London (1957)

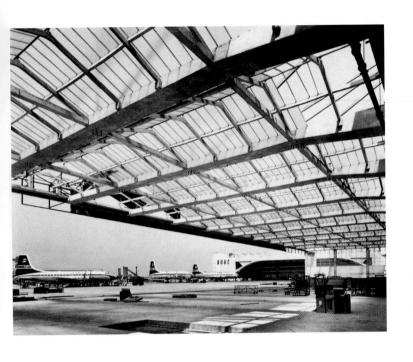

fig. 59

**BOAC Maintenance Headquarters,
Heathrow Airport, London** (1957)

Architects/Engineers:
Sir Owen Williams & Partners

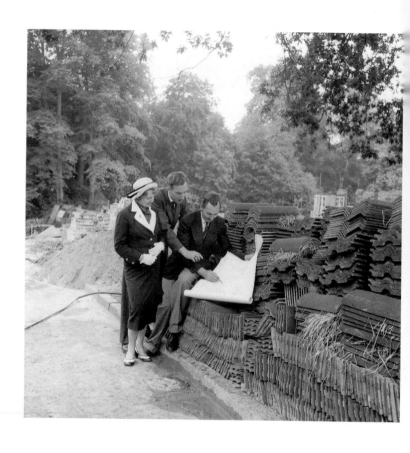

fig. 60

'Mrs. Castle choosing houses at Southampton'
(1958)

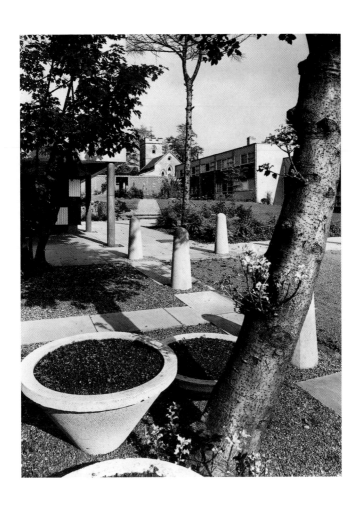

fig. 61

**Span housing, The Priory, Priory Park,
Blackheath, London** (1957)

Architect:
Eric Lyons

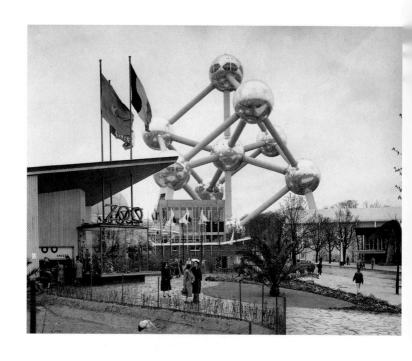

fig. 62

Atomium,
Exposition Universelle et Internationale de Bruxelles (1958)

Architects:
A. & J. Polak

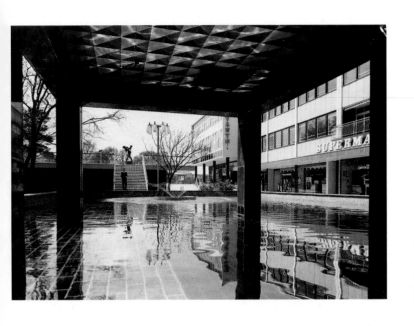

fig. 63

**Shopping Centre,
Stevenage** (1959)

Architect:
Leonard G. Vincent of Stevenage Development Corporation

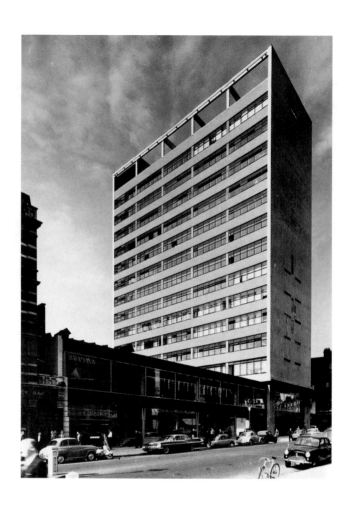

fig. 64

Thorn House, Upper St. Martin's Lane, London (1959)

Architect:
Sir Basil Spence

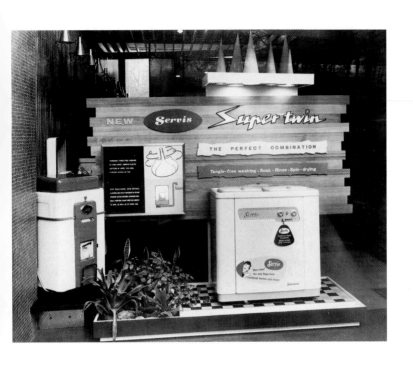

fig. 65

New Servis Supertwin washing machines
(1959)

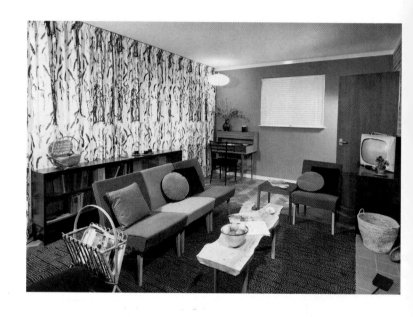

fig. 66

Sitting room, house at Leverstock Green
(1960)

Architect:
Peter J. Ball

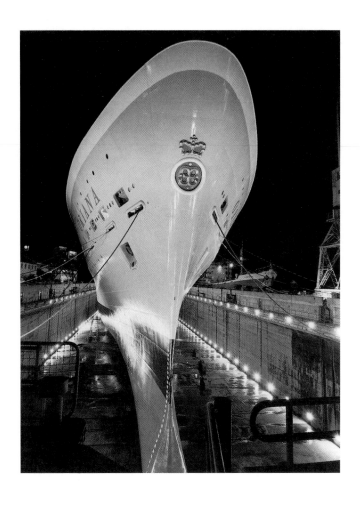

fig. 67

S.S. Oriana docked at Southampton
(1960)

Designers:
Design Research Unit

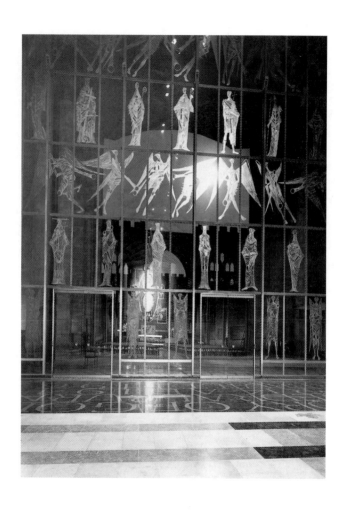

fig. 68

**John Hutton's engraved glass west window,
Coventry Cathedral** (1962)

Architect:
Sir Basil Spence

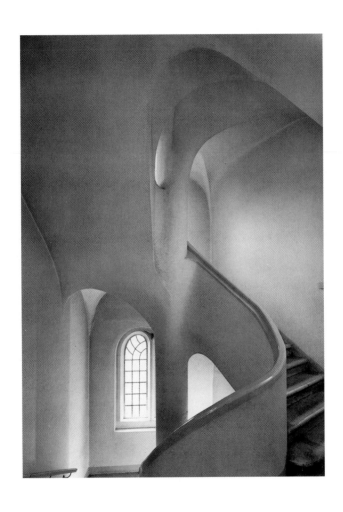

fig. 69

**Rudolf Steiner House,
Park Road, London** (1962)

Architect:
Montague Wheeler

fig. 70

**New Ocean House,
London Wall** (1963)

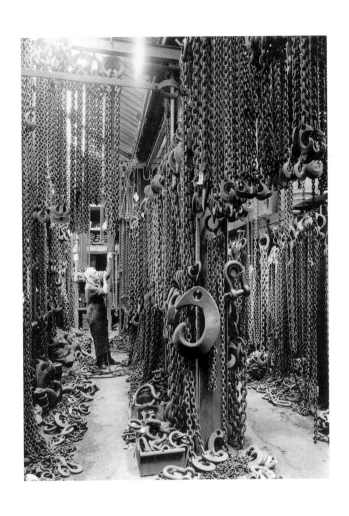

fig. 71

**Chains at W.S.E. Moore Ltd.,
Poplar, London** (1963)

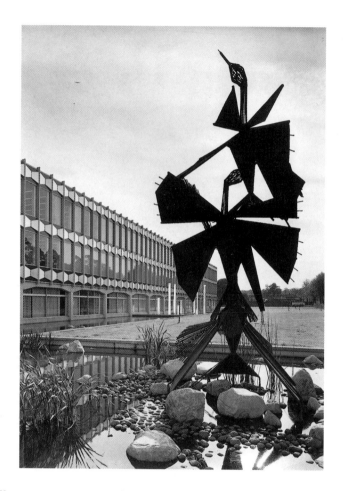

fig. 72

**Bird's Eye headquarters,
Walton-on-Thames** (1963)

Architects:
Sir John Burnet Tait & Partners
Sculptor:
John McCarthy

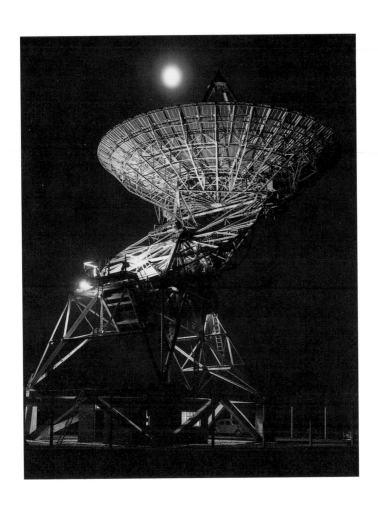

fig. 73

**Mullard Radio Telescope at Lords Bridge,
Barton, Cambridgeshire** (1964)

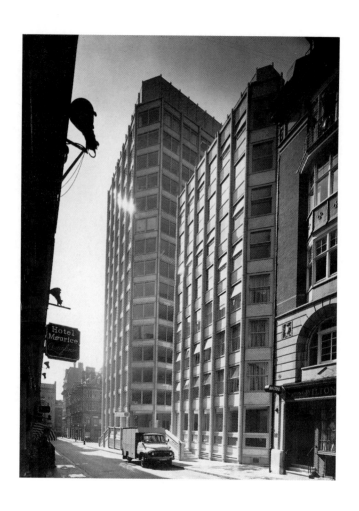

fig. 74

**Economist Building,
London** (1964)

Architects:
Alison & Peter Smithson

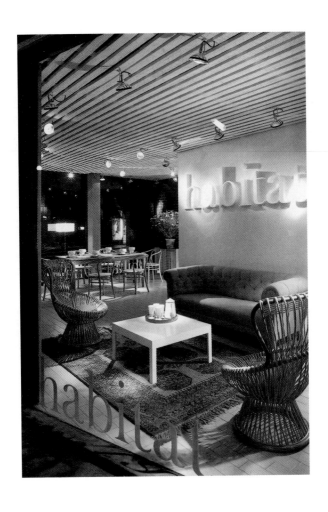

fig. 75

**Habitat, Fulham Road,
London** (1964)

Designers:
*Sir Terence Orby Conran
and Oliver Gregory*

103

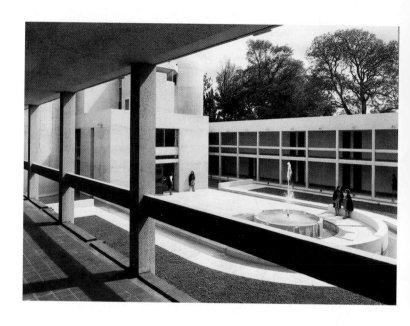

fig. 76

**New Hall,
Cambridge** (1965)

Architects:
Chamberlin Powell & Bon

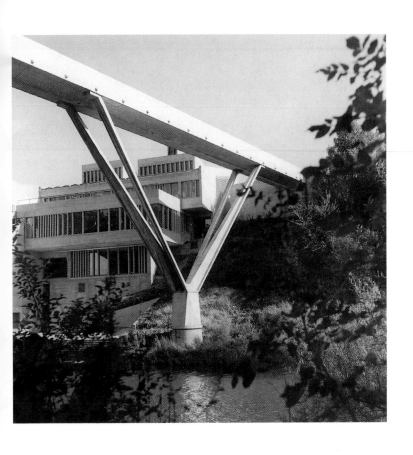

**Kingsgate Bridge and Duneld House,
University of Durham** (1978)

Architects:
Ove Arup & Partners / Architects Co-Partnership

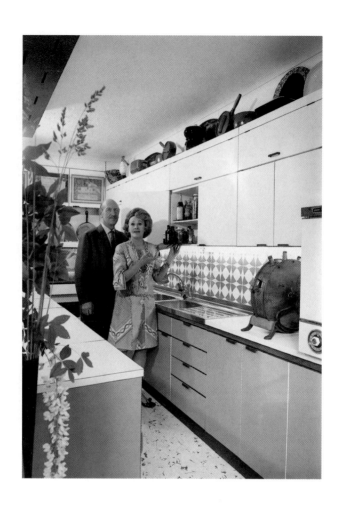

fig. 78

**Popular cookery experts
Fanny & Johnny Craddock
in their Hygena kitchen
(1969)**

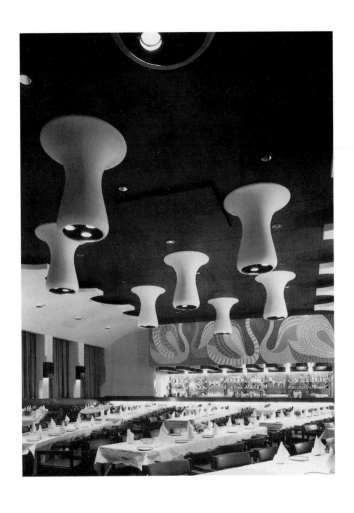

fig. 79

**Ballroom, The Swan,
Yardley, Birmingham** (1967)

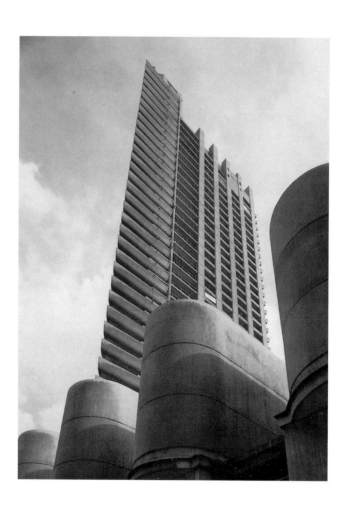

fig. 80

**Barbican,
London** (1970)

Architects:
Chamberlin Powell & Bon